Happy Christmas
all year long;
Gary

The
The Christmas
Book

Drawings and musings by
Gary Maggio

for
Barbara Jane

In December of 2020, a friend suggested I make a book of a collection of my Christmas drawings that have mostly accumulated in my basement over 30+ years. At the same time, it became clear that Barbara and my traditional Christmas Eve open house would not take place. Masks or not, no people in our world were gathering indoors in groups. It was, sadly, a Christmas unlike any in our lifetime.

I'm a great fan of the artist and writer Maira Kalman, and felt a book inspired by her — that is, a book filled with a few personal anecdotal stories accompanied by my drawings — was what I hoped to create. Perhaps one challenge was that my early connections to religion, to ritual, to holiday gatherings, were, in my memory, off-kilter and as often as not a bit dark, or at least uncheerful and unnecessary, while my drawings are mostly celebratory and whimsical.

Bringing them together—relying totally on the knowledge and skills of my designer friend Joan Greenfield and my artist friend Carol Richards—has resulted in this book. To think that those old stories and family memories would stand so beautifully in contrast to the Christmases that Barbara and I have shared was worth documenting. So I thought, and so it is.

The Christmas Tree

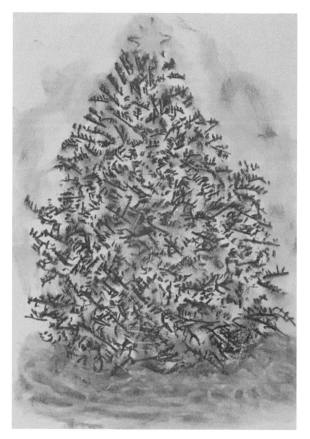

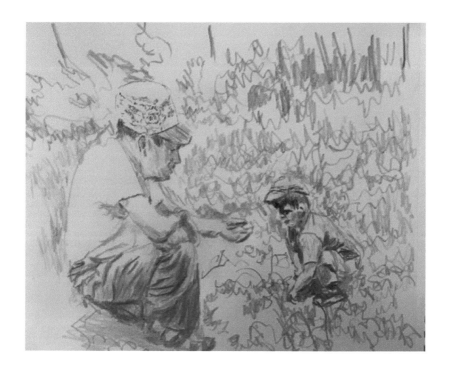

My father was an avid gardener, which was not unusual for a second-generation Sicilian from Coney Island. Gardening was in his blood and in his thumbs. It was also a release from the angers, frustrations, and bitterness he could never seem to escape. He never grew firs or pines — he was more interested in flowering things like roses (we had 96 bushes—I counted them) and dogwoods, and mimosas that were never successfully grown.

When my family was home together during my teen years, we had a fake half-Christmas tree that my mother insisted was a Hanukkah bush. I remember none of the decorations; perhaps there were none.

But in my near-half century of marriage, we have had a freshly-cut Christmas tree every year. Barbara decorates it wonderfully with carefully chosen small white lights, hand-made red ribbons, and a lifetime of ornaments from our travels and our children.

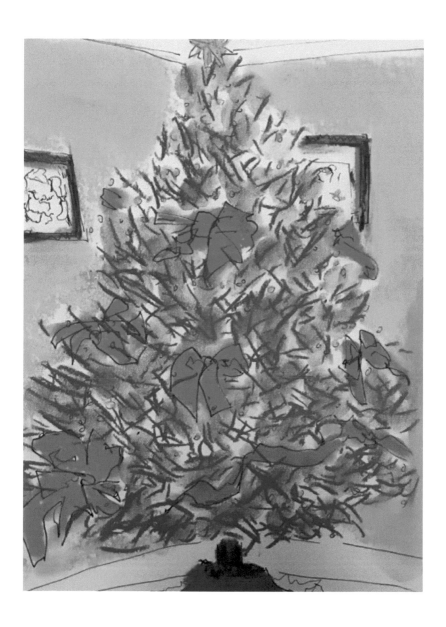

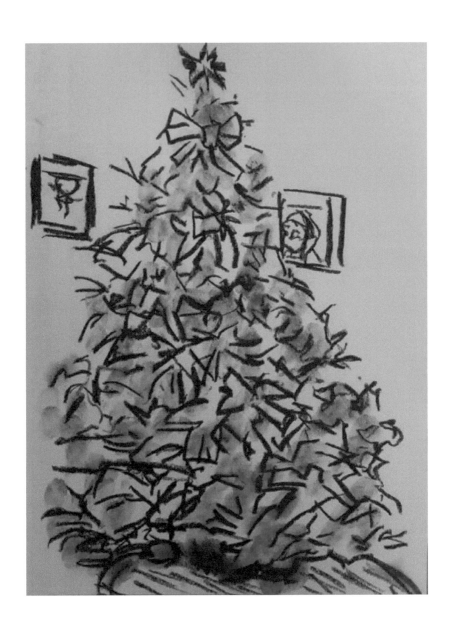

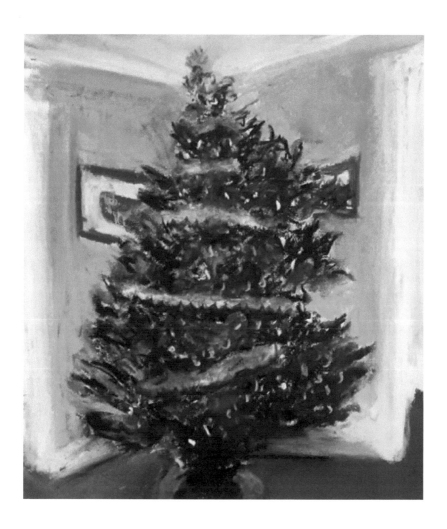

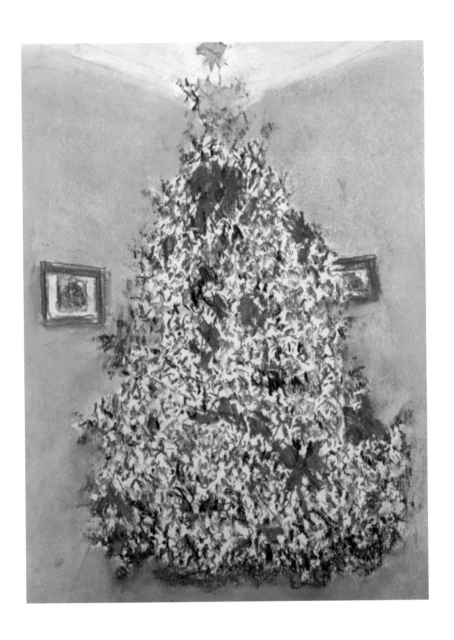

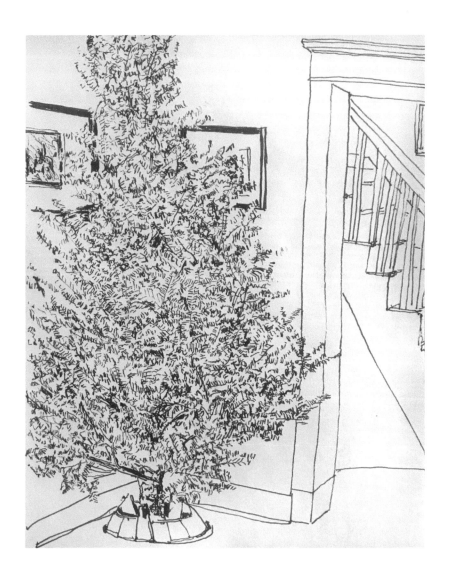

I love Barbara's Christmas trees.

Everyone loves Barbara's Christmas trees.

Angels

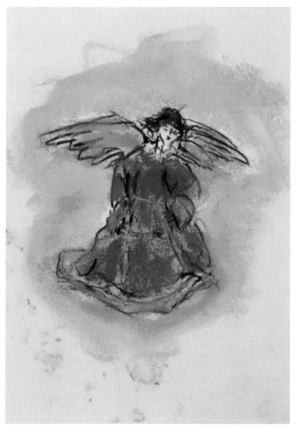

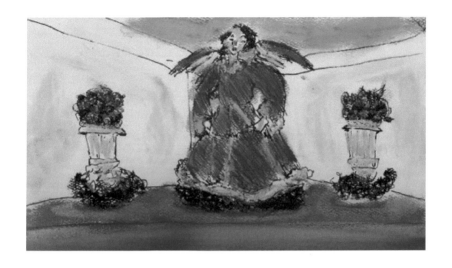

I wonder what angels have to do with Christmas? Growing up on Long Island, there were many Jews on my street, including my mother's Mah Jongg friends Lorraine and Reggie. Lorraine's children were Anita and Mona, who were no angels. Mona would knock on our front door uninvited until my mother had enough of her little mousiness. Through the curtains she saw the little girl coming across the street and before she had a chance to knock, my mother, usually a fearful worrier, swung open the door and said, "Bastard, bastard, bastard, bastard, bastard!" It's true; family lore.

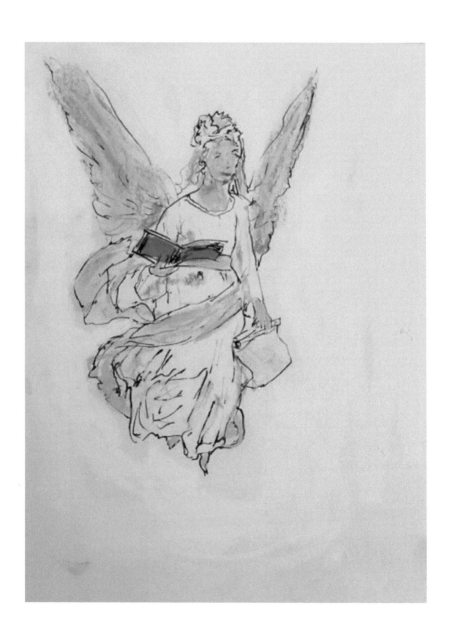

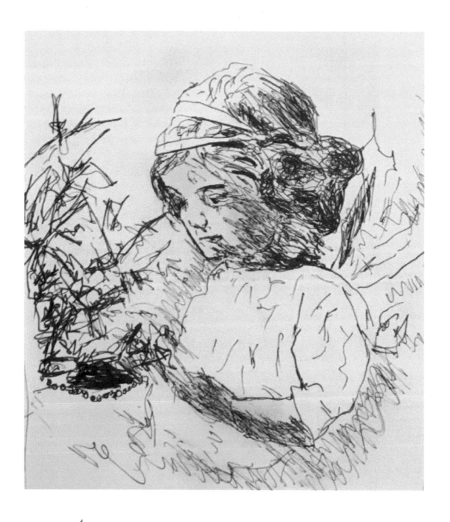

My mother's childhood name on Coney Island was
Sarah Spiegel, but everyone called her Sally,
which made her more American I suppose, but it took
something from her in the long run, I think. I don't
know if there's an angel named Sarah, but it's a good
name for an angel—it means Princess in Hebrew.

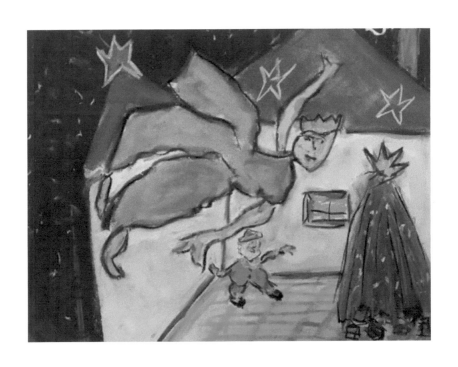

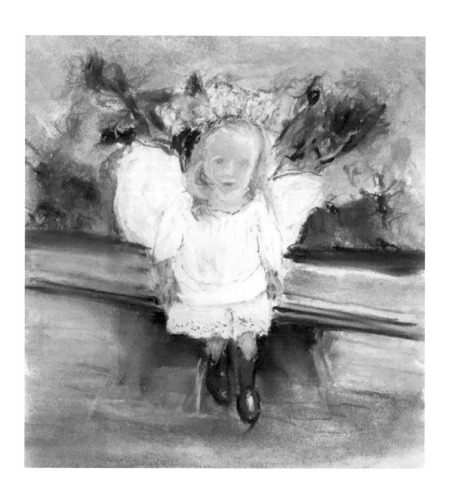

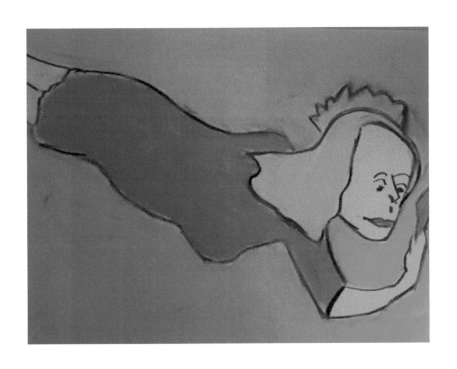

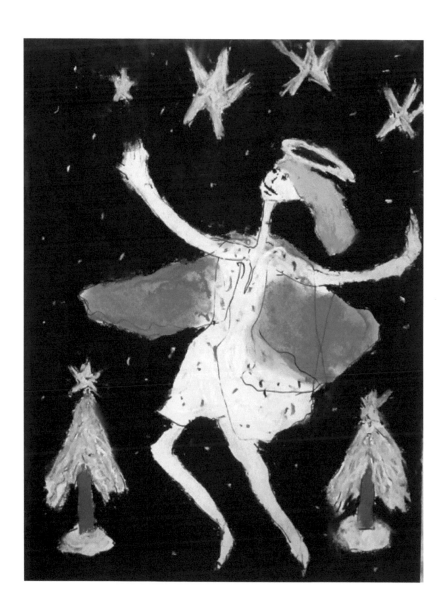

Rudolph

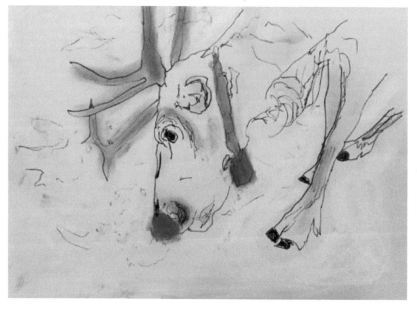

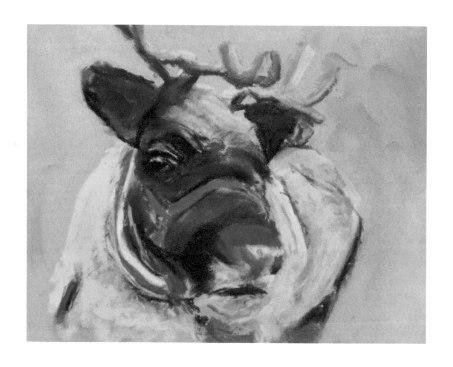

In the Northeast, Rudolph lights our way through
cold and dark December. He is a quiet, stoic, gentle
leader. Because of him, Christmas is never anything but
warmly lit. There may be someplace in the world—in
Finland at least—where reindeer are spiritually spoken
of in myth, like the Buffalo or the Sacred Cow.

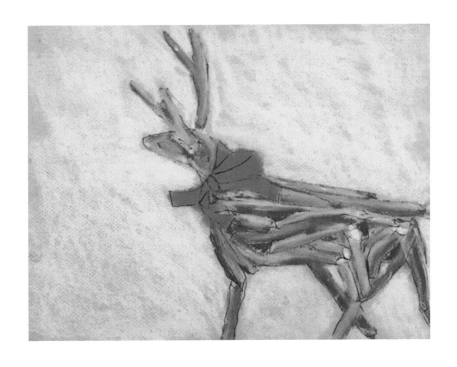

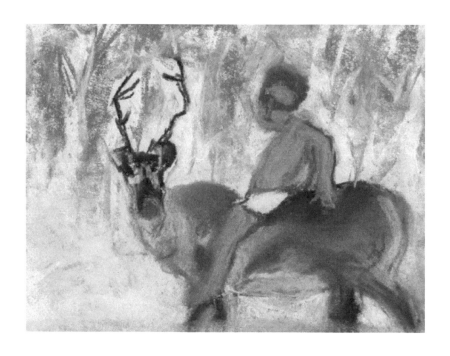

In the middle of one Christmas Eve party at our home, niece Katie, perhaps five, wanted to take a walk up my street, so we left the noise and celebration behind us and, hand in hand, one small step at a time, our eyes raised, the sky dark, Katie's cheeks imbued with neighbors' outdoor Christmas lights, I pointed at a bright red star moving slowly high above us. "There he is," I said," undoubtedly." And she was quiet and her eyes glistened.

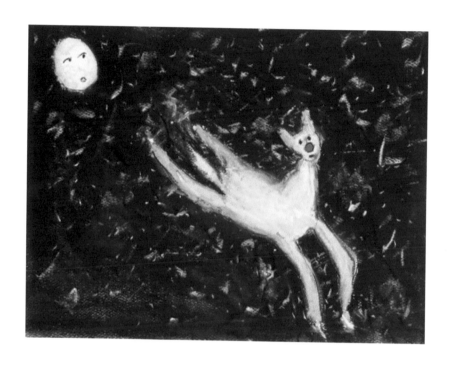

Santa Claus

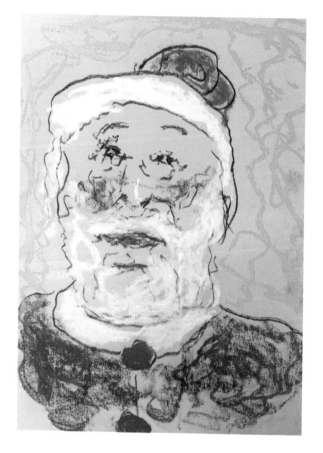

We spent my early Christmases visiting my father's parents in the old house in which they retired in a town called Clintondale, in the Midwest Hudson Valley. *We're going Upstate,* we'd say.

My grandfather Salvatore had been a New York City cabbie. My grandmother, whose first name I can't or won't remember, raised three daughters and a son but was never fat. A little bit of fat might have softened her, but I doubt it. We children called them Gramps and Granny, indecorous, chilly titles that seemed to suit them.

I remember trying to go to sleep in Gramps' and Granny's bed on Christmas eve, with my sister beside me, in the early evening in their room at the top of a metal spiral staircase. I lay awake as long as I could, listening to the raucous game of pinochle played by the Sicilians and their spouses in the dining room just below us. We would be awakened after midnight, slowly wind our way down the spiral staircase, and find the tree decorated with tinsel and lights and many, many presents.

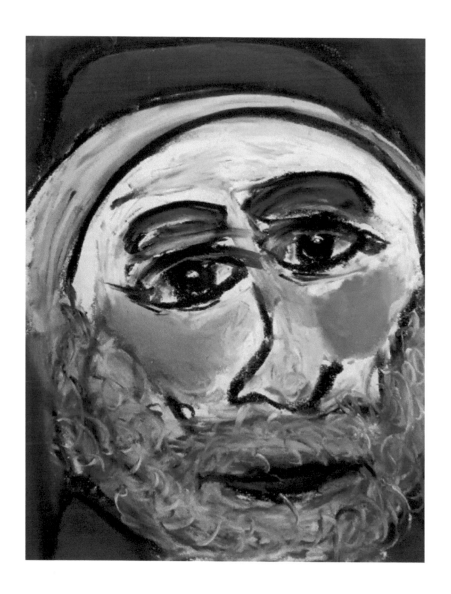

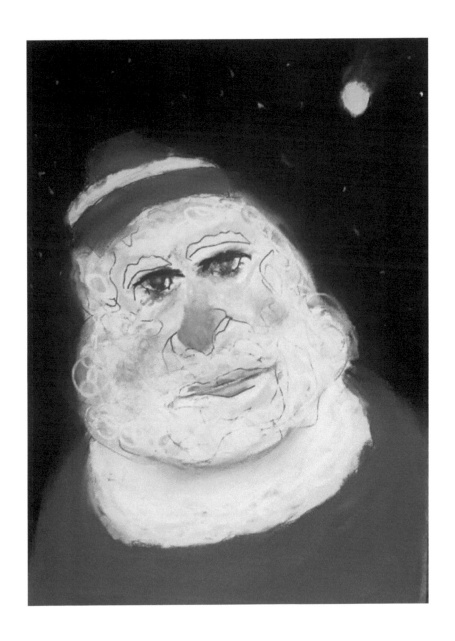

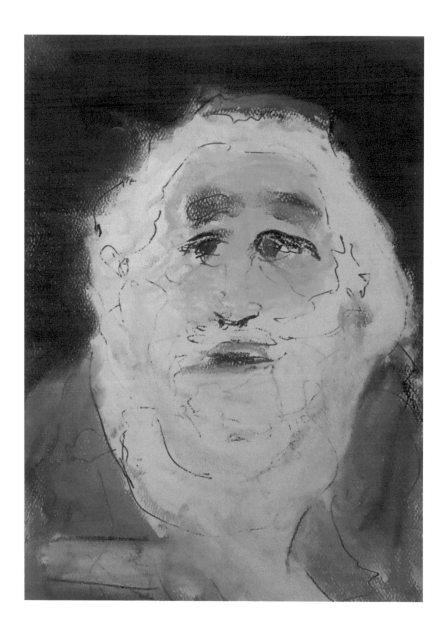

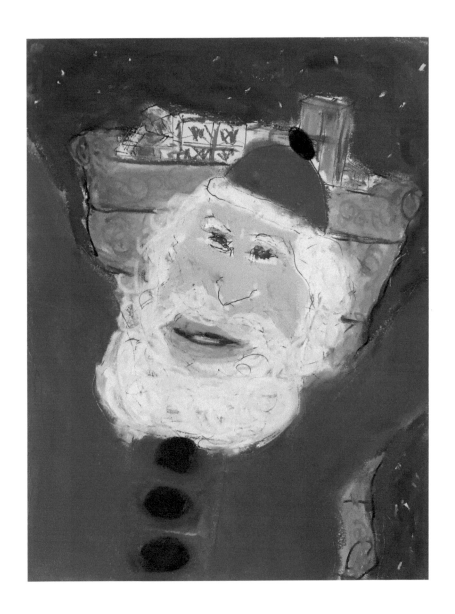

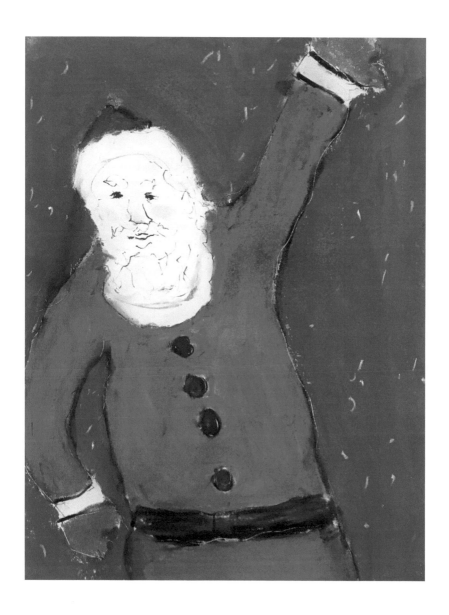

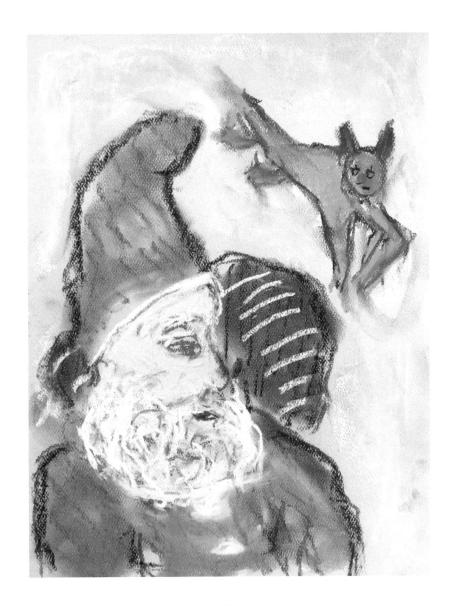

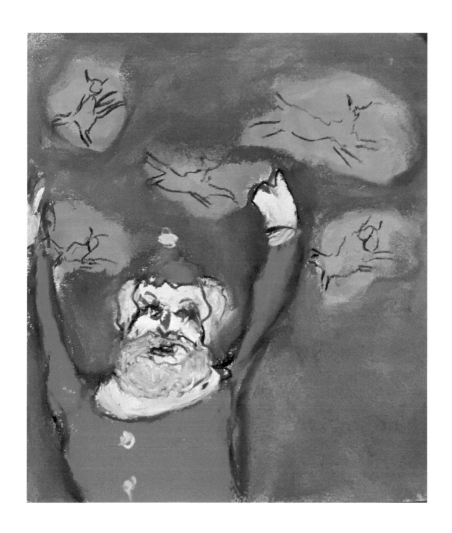

I don't have much of a Santa Claus memory; among the men in my family none ever dressed as him. One Christmas Eve was unforgettable for all the wrong reasons. The youngest of the cousins, Debra, was maybe five years old but already disliked by most of the family because of her whining. She was acting badly, I guess; whining, I guess. Her parents and aunts and uncles had no patience for it and told her that if she didn't see Santa Claus flying away from the house, she probably hadn't gotten any presents.

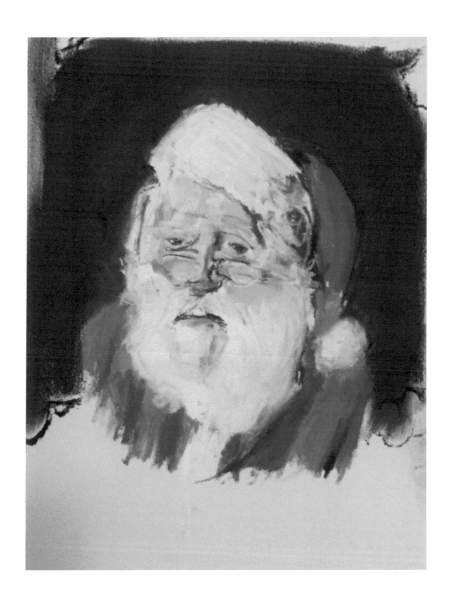

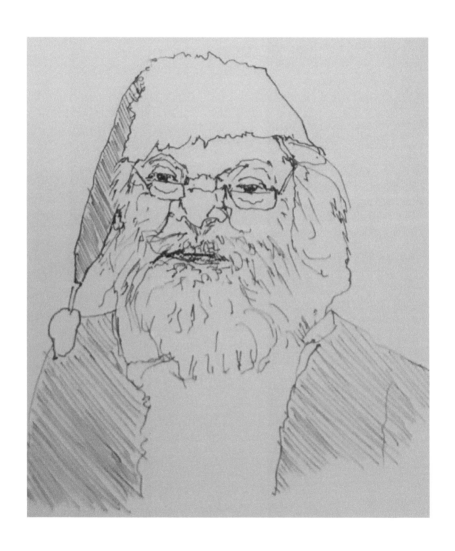

When little Debra came down the stairs there was a side
door with a window. Three or four adults blocked the
window from her view, and waved: "Goodbye, Santa!
Goodbye, Santa!" I'm sad to think I remember my
mother was among that group. In my memory, Debra's
screams were high-pitched and deafening. But oddly,
she grew into a lovely adult and oddly too she became
close friends with my mother after my parents divorced.

Snowmen

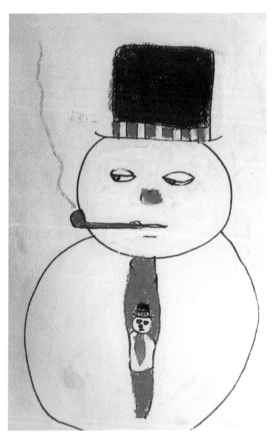

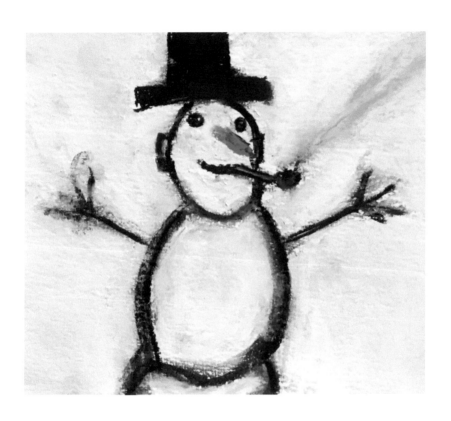

One winter in the early 1980s, we lived on Parkwood St., a short stretch of one and two family houses. Barbara and I lived on the main floor of a new building. Across the street lived Patti and Dave, our dear ones recently moved from Colorado, who were fortunately as silly as we were. One bright Sunday after a winter storm, we four began a snowman, taller than us all. Magically it started taking the form and wide curves of a giant woman who reminded me uncannily of a former colleague I particularly loathed. The Snow Lady assumed the bad lady's name, her presence on a tiny little block an enormous warning to small children and pets.

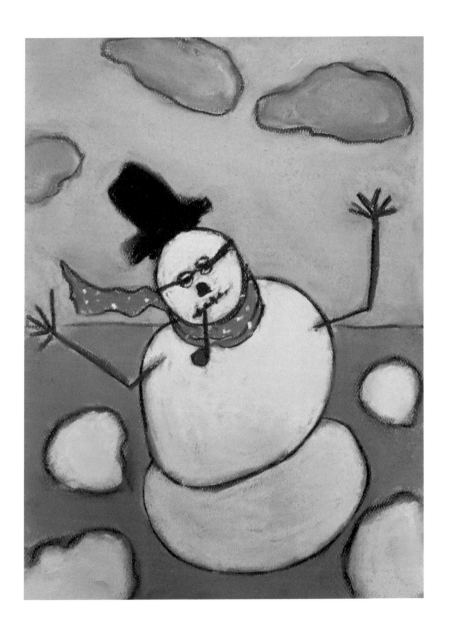

Years before, in Rochester for Christmas, little
Carol, the youngest, had a bunny curiously named
Portius. On a freezing night before the Eve, Carol, Patti
and I ventured to sculpt a snow bunny in their comfy
backyard. The little girls' cheeks wet and raw and our
eyes delighting in the process—Carol the bunny expert,
Patti the expert on form and perspective, and me, the
laborer—we created a temporal masterpiece, if one
called our pleasure in the forming and the final product
the signs of genius. Who were we then who grew
into the adults we now are fifty years later? Have we
forgetten how we marveled at the possibilities of snow?

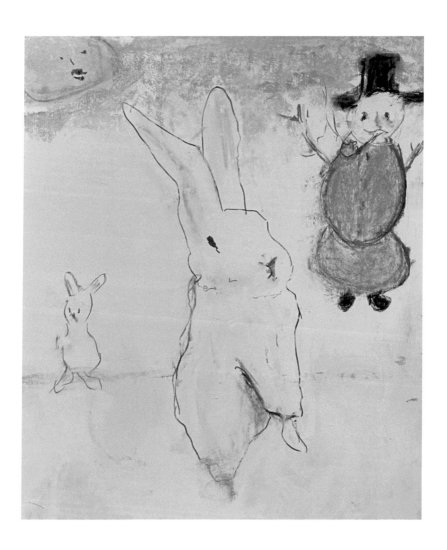

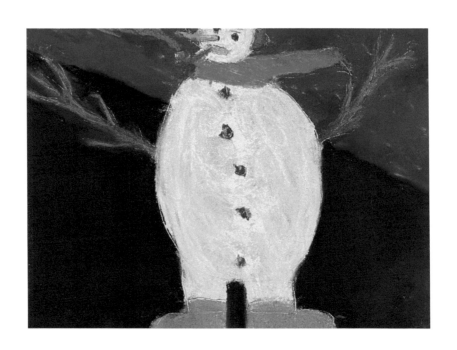

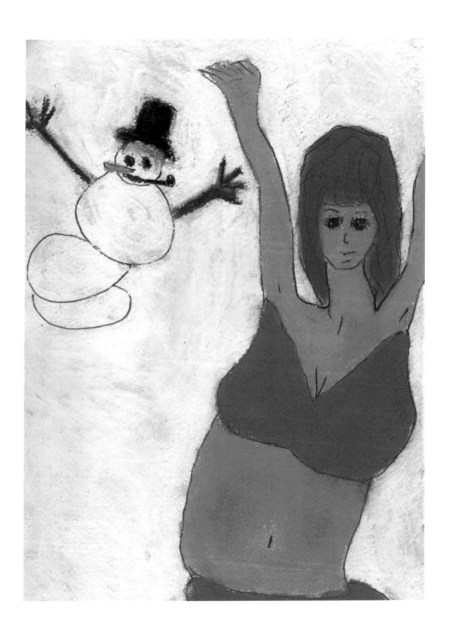

Christmas in the City

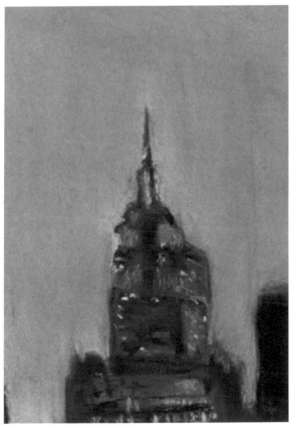

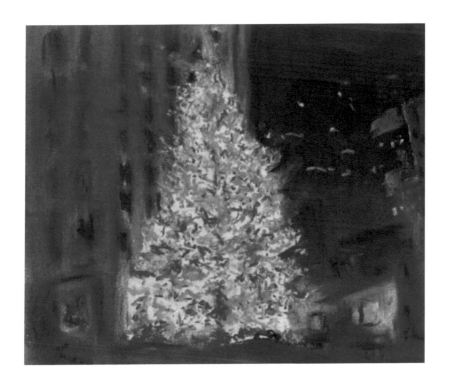

New York is where Christmas began for me, because
Barbara loved it. In the fortnight before Christmas,
we would stroll together down Fifth Ave., looking in
the windows and viewing the tree and skaters and the
children at Rockefeller Center. But mostly she went in
and out of delightful, family-owned gift shops brightly
decorated, while I held the already-bought presents and
sat on the ledges outside the shops, breathing in the
bustle and the color and the terrific chill of the city air.

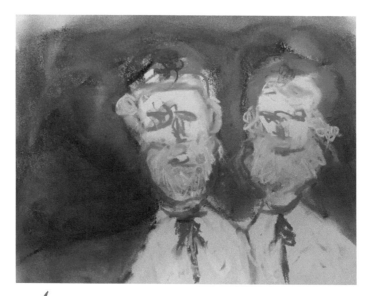

Much wonder and sadness have happened in and to the City since we left in 1980, but its music and intimacy and surprising kindness remain in my pores palpably.

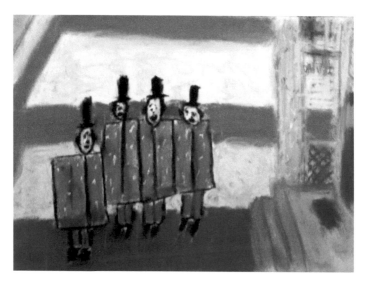

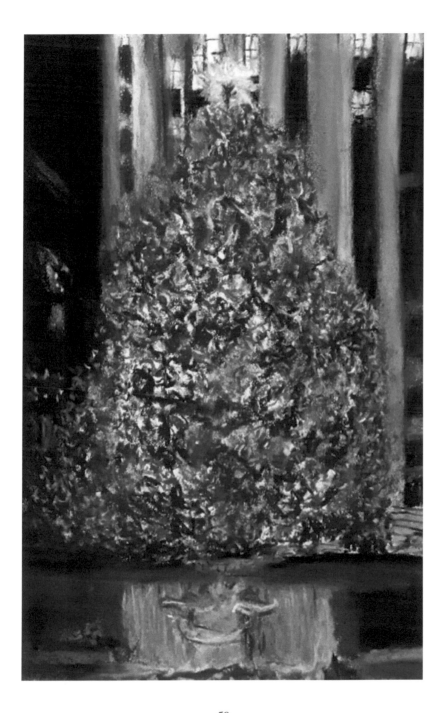

.

Christmas at Home

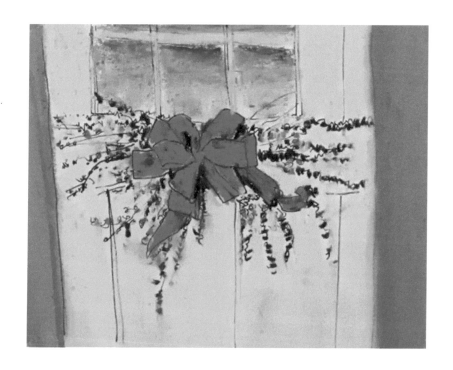

My home is the Place of Christmas, made warm and sweet and spiritual by Barbara, who loves and creates Christmas every year. Our house is old and not fancy, but you would never know it. She makes it a jewel box, a sparkling story, a place where children gasp and adults regale, friends meet strangers. People tall and small, dark and light, Christians and pagans all find comfort and Christmasy smells and tastes and simple beauty for a few hours every December 24th.

64

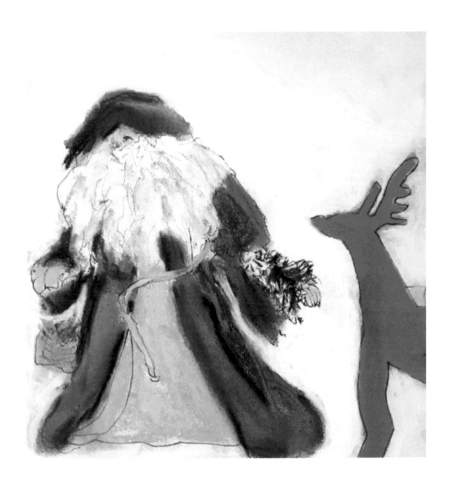

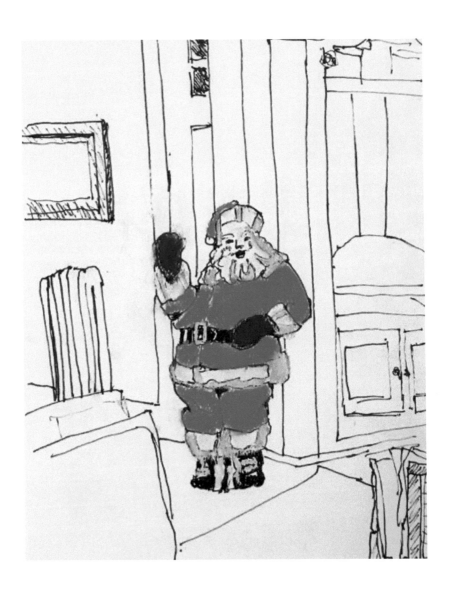

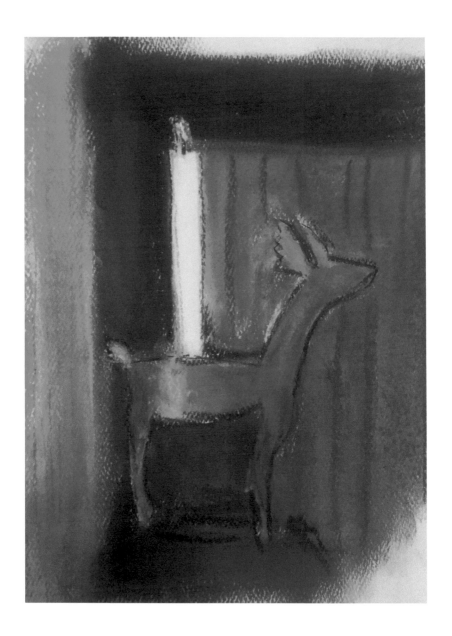

We finally had our first house after 14 years of NYC Christmases, where we had accumulated memories and ornaments and funky presents and loved our friends Joan and Lou and Bill and Al.

Now twelve of us gathered on Christmas Eve 1987 to celebrate our old Albany house and new babies and sing at the dry old baby grand. Some of the original twelve are gone now, dearly departed or in the rear view mirror; still, the party grows, and those who can come do, 30 or 40 or 50 strong, and remove their overcoats and boots on the porch and bring sweet and savory things to eat and dry and sweet things to drink and talk about.

They stay, new and old friends, and stay and stay and eat and laugh and drink, and for one night we are all a family. The weeks Barbara has spent on decorating the house bring a warmth to every room with candlelight and bows and Santas and a hopeful mistletoe hanging from the hall chandelier. And people eat my food and theirs, and stay and stay, never wanting to leave, wanting the moments of easy celebration to never end.

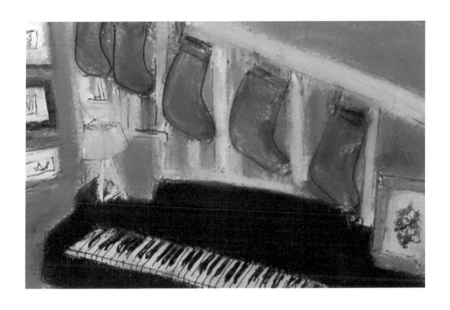

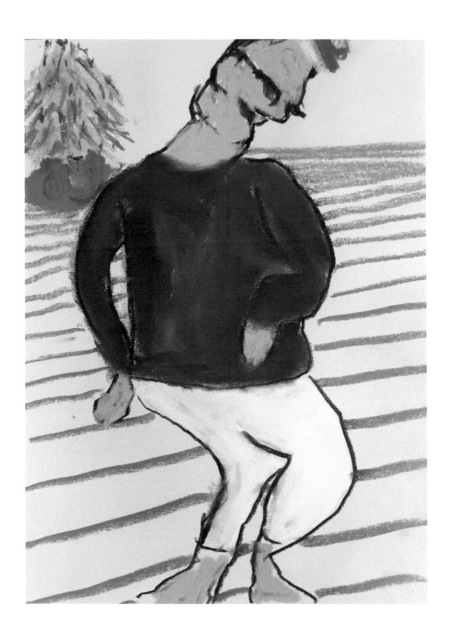

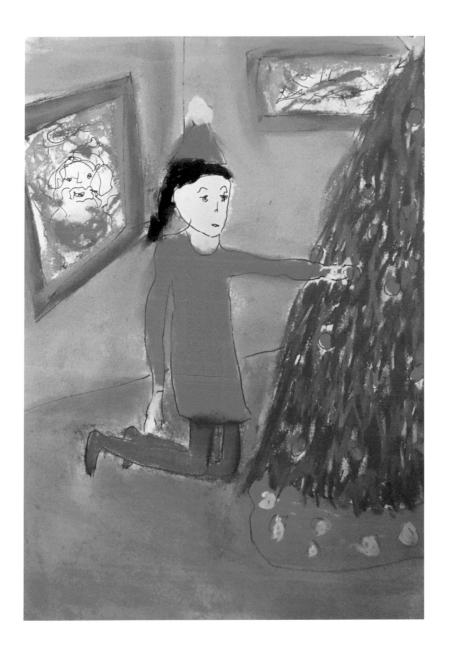

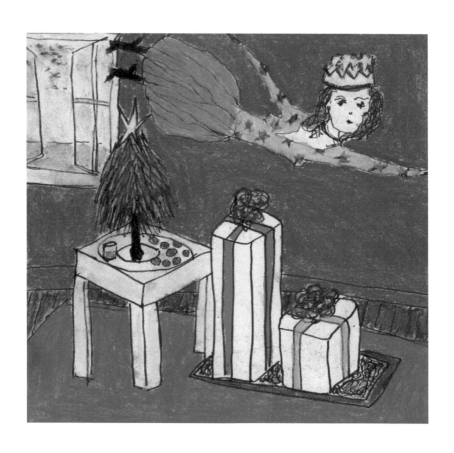

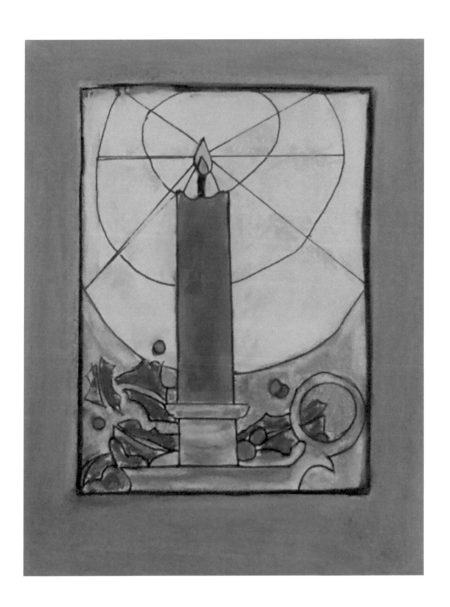

Special thanks

Joan Greenfield, who designed this book and helped edit it, and without whose dear heart, smart skills, and great friendship this book would not have been done,

Carol Richards, an essential adviser, who has believed in me forever and who is wiser and more wonderful than she knows,

and

Laura Vecsey, who said to me one Christmas, "You should make a book of these drawings."

This book is for Barbara Jane, who is my Christmas, my Birthday, my Halloween and Easter and every day in between love and reason to keep going.

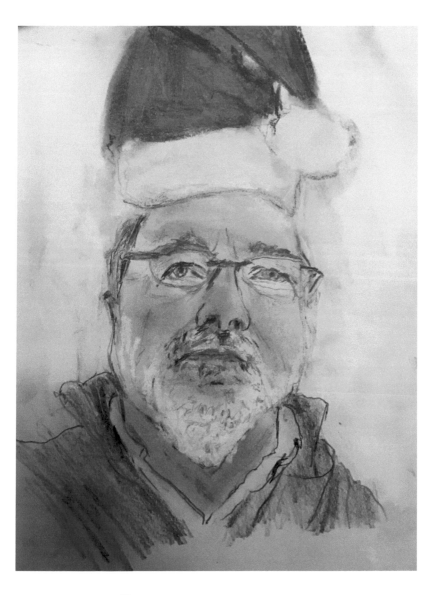

Gary Maggio is an artist and poet.